BEACH NOTES
by Cat Ruiz Kigerl

ISBN 978-0-9981564-6-0

eBook ISBN 978-0-9981564-7-7

TwoNewfs Publishing
Seattle, Washington

Also by Cat Ruiz Kigerl

Stirring up the Water

At the Town Café

Contributing Author
New Halem Tales

Beach Notes is a meditative poem series composed while

walking a local beach during the COVID-19 pandemic. I began to

write it as a way to heal from a personal loss. Through the poems I

see nature as it is, and strive for hope, and healing for all. The poems

and photos were all composed on my old cell phone.

Cat Ruiz Kigerl

Tuesday, Feb 18. 1:11p.m.

To be on the beach without yearning for the past.

Sun sparkling on water. Birds floating offshore.

There is only this.

Thursday, Feb 20. 1:26p.m.

The beach is a salve for healing from losses

"too great to understand. That rove after you."[1]

The rocky shore is still and sculpted, like a Zen garden.

[1] Stafford, William. "Reaching Out to Turn on a Light." *The Way It Is: New and Selected Poems.* Graywolf Press, Saint Paul, Minnesota, 1998.

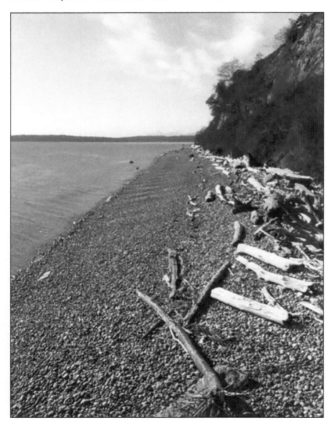

Friday, Feb 21. 1:49p.m.

Reluctant to leave the beach behind.

Disengaging from the past a minute at a time.

Across the water, a train crawls along the shore.

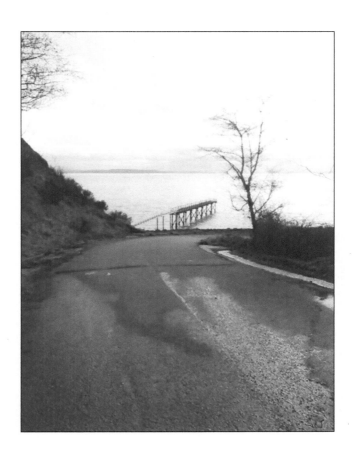

Monday, Feb 24. 1:27p.m.

A dog follows me today. The beach is ours.

Does he have a master?

It is going to rain.

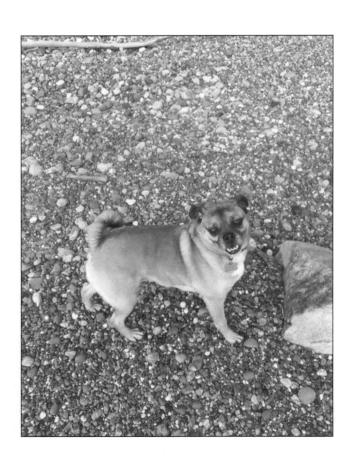

Tuesday, Feb 25. 12:37p.m.

It is a grey sky day. The tide is out.

On the horizon the mountain is chalky white.

Some days are hard, some easy. There is again a sign of rain.

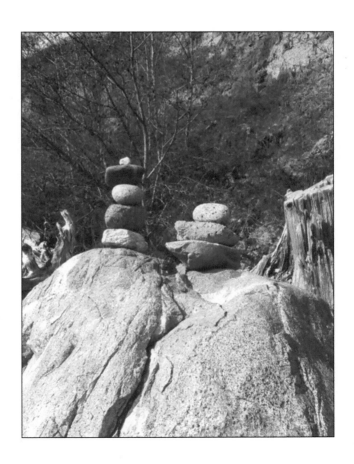

Wednesday, Feb 26. 1:06p.m.

Diamond points sparkle upon the water.

Sunlight's illumination replaces the grey.

Today there is no sense of grief.

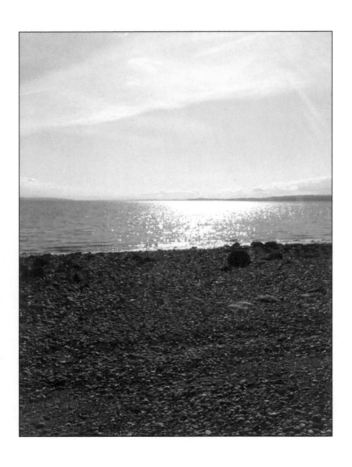

Friday, Feb 28. 12:24p.m.

Is anyone ever truly sharing life with another?

Can another's presence be visceral?

The driftwood lay abstractly upon the beach.

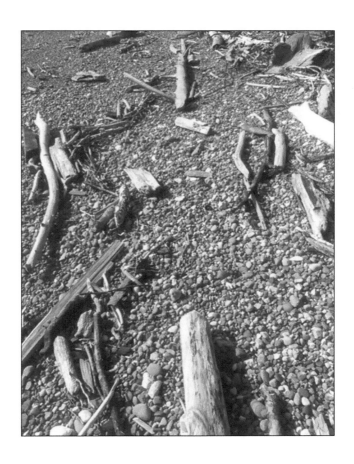

Sunday, March 1. 1:02p.m.

Rain sprinkled. Then there was the sun.

Every minute is a change.

Youth, old age and death.

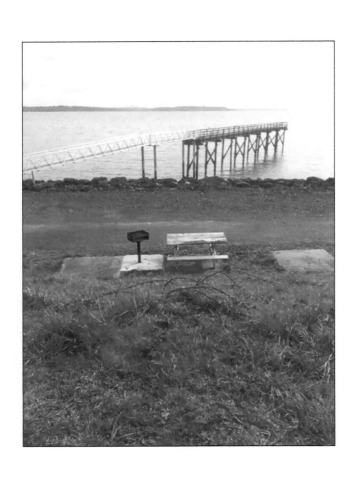

Tuesday, March 3. 1:03p.m.

The beach is stormy. I visit the high surf then climb the hill.

A virus creeps into the city across the water.

It creates fear across the world.

The wind blows hard over the bluff.

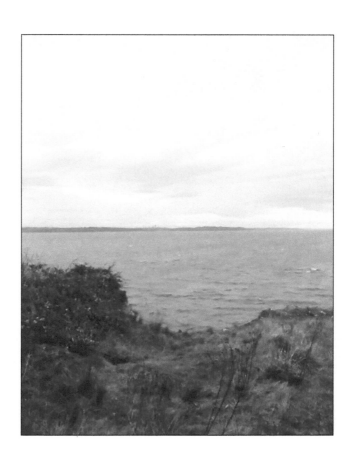

Wednesday, March 4. 2:45p.m.

On the beach it does not matter that people do not listen

to warnings about the virus.

The tide slowly goes out.

An oyster shell is bleached by the sun.

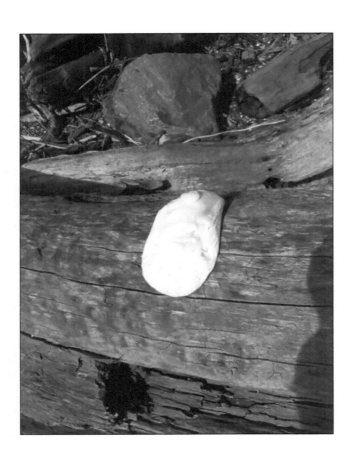

Sunday, March 8. 1:10p.m.

The beach, a home at the end of the road for those who find it.

The wind is chilled.

The sun is striving to warm.

One must keep looking up.

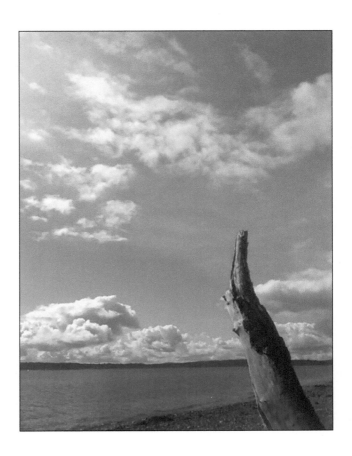

Monday, March 9. 2:23p.m.

Many eagles bless the beach, whistling as they greet the sky.

Seals pop up and then are gone.

The city is quieter on the other side.

What is here, today?

Wednesday, March 11. 1:49p.m.

The beach is filled with life. Many seagulls feed offshore.

Seals bark and play.

A pandemic has now been declared.

The sun sends rays onto the water through the cloud.

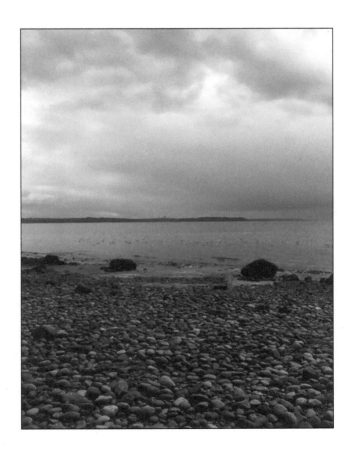

Thursday, March 12. 1:18p.m.

There are those who have no beach.

There are those who are isolating from the virus in the city.

The water is calm, the tide at ebb.

Only the seagulls cry.

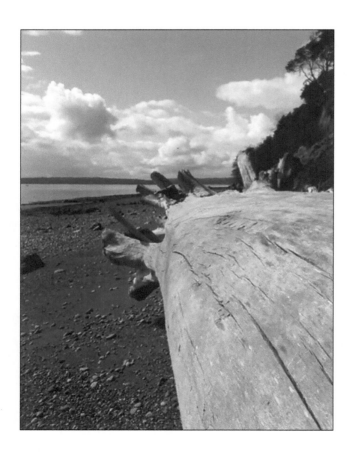

Saturday, March 14. 2:13p.m.

It is a cold day but the sun is warm on the beach.

There are two passing seals. A ship moves in the distance.

Is there anything truly amiss?

A madrona tree clings to the cliff.

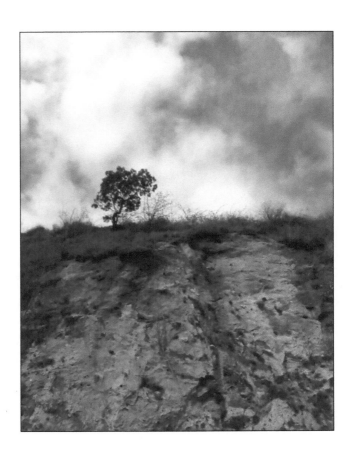

Monday, March 16. 12:33p.m.

It is a blue sky day. Will this isolated beach stay open?

The virus cannot cross the water without a host.

A sailboat. The far mountain hidden by clouds.

This too will pass.

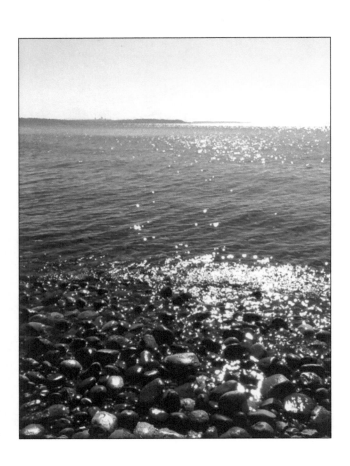

Tuesday, March 17. 12:59p.m.

At slack tide. Gulls paint the dock. There are trials

of sharing an abode in isolation.

Pleasure becomes relative.

An old radio playing at lunch. The quiet beach in the afternoon.

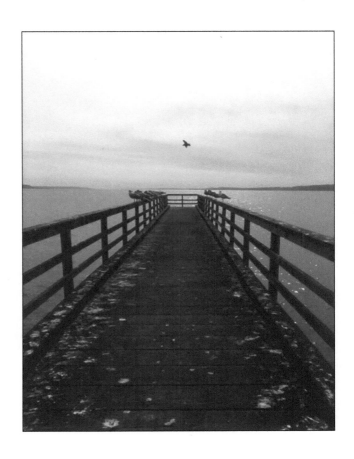

Wednesday, March 18. 1:37p.m.

The beach, an undisturbed temple. The waves roll in.

A helicopter flies toward the city.

Three loaded freighters pass slowly.

A group of harlequin ducks feed in the surf.

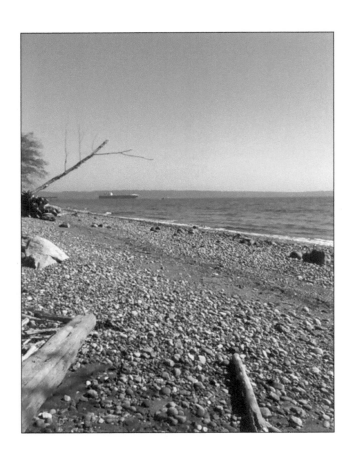

Thursday, March 19. 1:15p.m.

Sparkling water. A hazy almost-Spring day.

The pandemic surges.

Yet there is tranquility in the midst.

A chickadee sings.

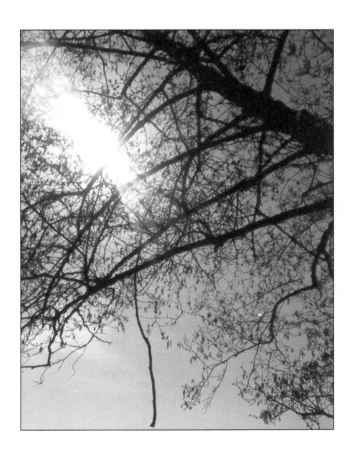

Friday, March 20. 1:49p.m.

So natural are the elements.

Their dance continues no matter.

The sky, land and surf are varied shades of blue.

A train's rumbling is carried across the Sound.

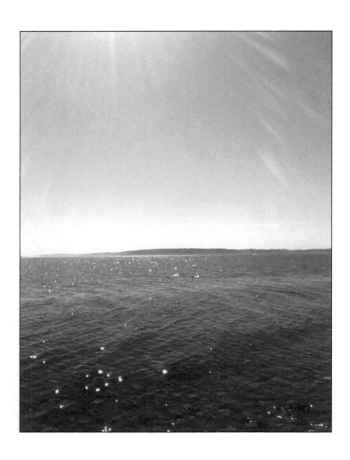

Sunday, March 22. 1:07p.m.

The beach, a place away.

Only the sea birds gather here.

A hidden log beneath a tree offers a private vantage.

The water is metal green under a pale sun.

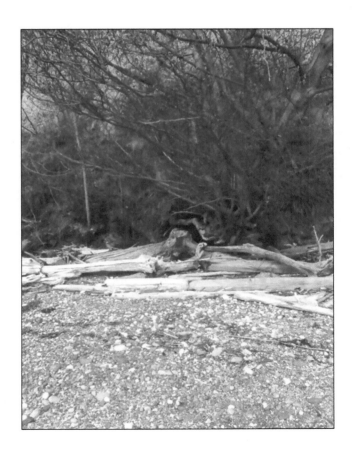

Monday, March 23. 1:29p.m.

Strange stormy, sunny day. Puffy clouds float above high surf.

Youth are as threatened by the virus as the old.

Sand dominates the beachscape, not rock.

Each day is different.

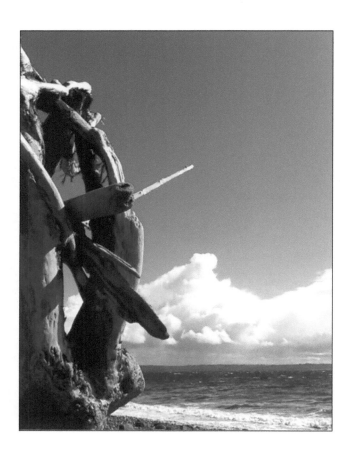

Wednesday, March 25. 1:00p.m.

Rain threatens from across the water.

A large military ship passes slowly.

The driftwood is shoved against the bank, immobile.

What is in this day?

Thursday, March 26. 1:02p.m.

The virus spreads locally now. More walk the roads.

It is a relief from lives lived indoors. But there is also fear.

A northeasterly continues to blow.

The waves splash outside the car windows.

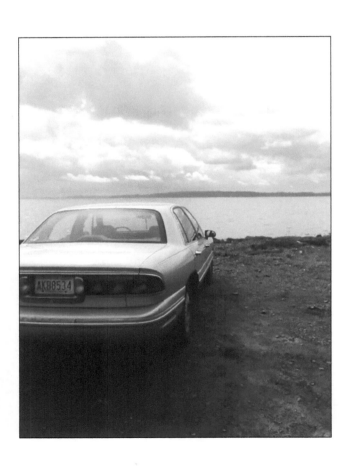

Friday, March 27. 12:47p.m.

Another stormy day. The beach, free from the strain of isolation.

The air is windswept clean.

A seagull can be envied when someone walks too close.

The water is antique grey.

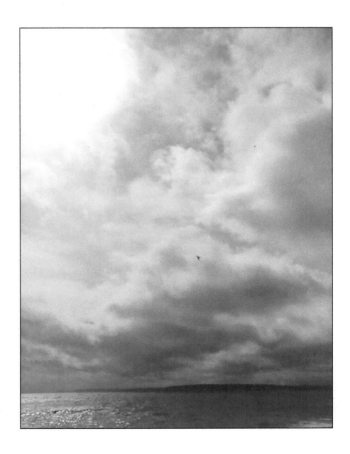

Saturday, March 28. 9:30a.m.

The tide is far in at morning. The waves crash close.

The virus has claimed the actions of the world now.

There are no decisions other than to stay put.

Robins sing on the bank.

Sunday, March 29. 2:00p.m.

A windy Sunday afternoon. Change happens swiftly.

Each twenty-four hours of health a blessing.

The waves are choppy.

The large rocks are vigilant.

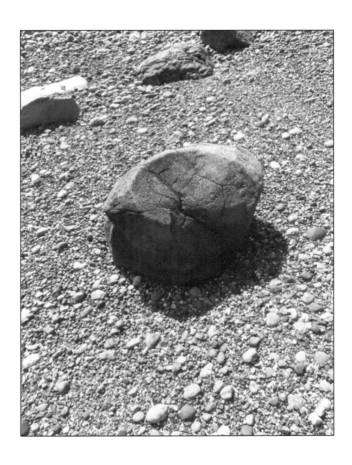

Monday, March 30. 1:08p.m.

There is a strong, cold wind and white-capped water.

The city buildings are faint mirages in the distance.

Is it now Spring?

Rain begins to pelt. Gulls push through the gale.

Tuesday, March 31. 1:11p.m.

An end of month sunshine promises as it glitters

upon the water. The waves dart forward then pull back.

A small boat speeds by.

Who or what listens?

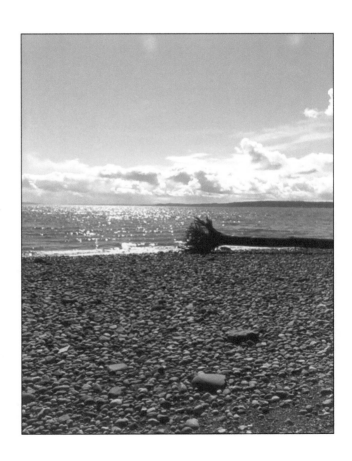

Saturday, April 4. 7:30a.m.

The tide is low at early morning. Few venture out at this hour.

Only a hawk is at his post in a tree.

A loon and two geese flap over the water.

There is peace and tranquility in a dawning day.

Sunday, April 5. 1:33p.m.

Art can be found on the beach. When nature creates

with a human-like hand. The waves arrive in huge swells.

A tugboat pulls a laden barge.

Life does continue on.

Monday, April 6. 12:38p.m.

The beach, a place one can be alone. With a spring breeze.

With old memories. With few strangers passing at a distance.

Changes come slowly or quickly.

The gulls frolic over the water.

Tuesday, April 7. 1:27p.m.

Some days the beach does not draw one to walk far.

At the slack tide.

An uncertain future pressing upon the heart and the mind.

The harlequin ducks are lined up at the shoreline.

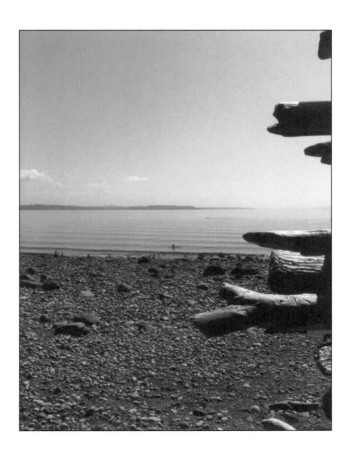

Wednesday, April 8. 1:13p.m.

A warm breeze. The tide way out. A fishing boat is beached

upon the other shore. Clam shells are scattered upon the sand.

It appears a calm day.

But inside stirs acknowledgement of too many changes.

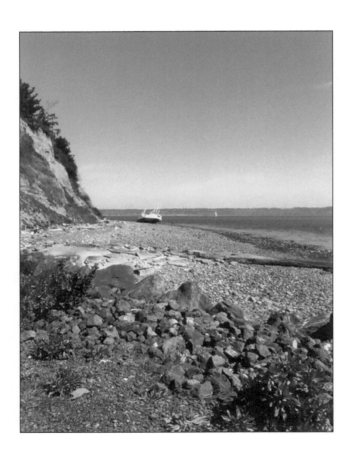

Friday, April 10. 12:55p.m.

There is death on the beach. There is decay at every step.

The landscape is barren on an overcast day.

Nature, like humanity, is always holding an edge.

Yet there is life amidst the rubble.

Sunday, April 12. 7:44a.m.

Easter morning at the beach. The waves peacefully lap.

Ducks and gulls float offshore.

There is a holy stillness.

There is the breathing in of fresh, pure air.

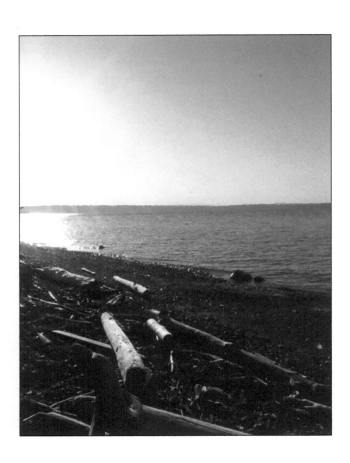

Monday, April 13. 1:00p.m.

Except for the cool breeze, it is a summer-like day.

Freedom can be found anywhere we see it.

An otter swims close to shore.

The sky is ultramarine blue.

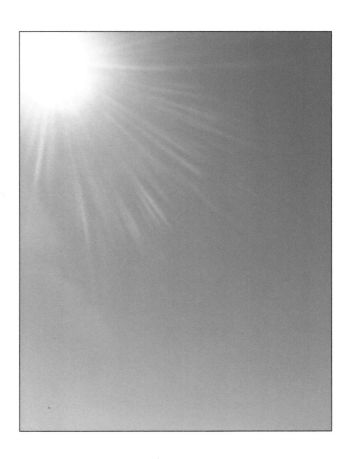

Tuesday, April 14. 12:53p.m.

Today the beach is a harbinger of change.

The past filtering away with the warm spring air.

Aloneness is a quiet joy.

Waves sweep in. Algae tints the water green.

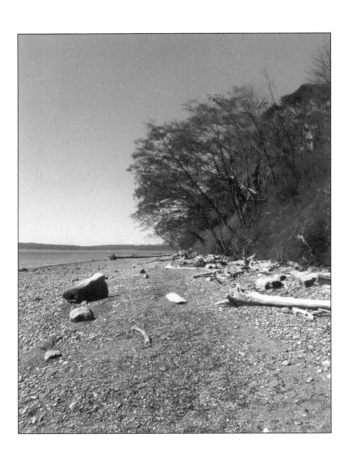

Wednesday, April 15. 8:35a.m.

The ducks are in a feeding frenzy this morning

on a current of smelt.

Rain clouds hover overhead. Yet the sky stretches.

The beach introduces expansion into this day.

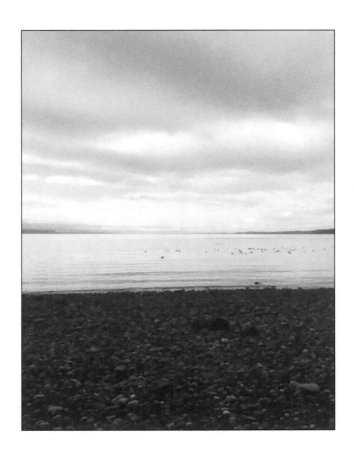

Thursday, April 16. 12:29p.m.

There is a soft spring breeze. The beach holds a quiet solace.

Pollution is lifting around the world.

Clear sky is now a given everywhere.

A kingfisher chatters as it flies past.

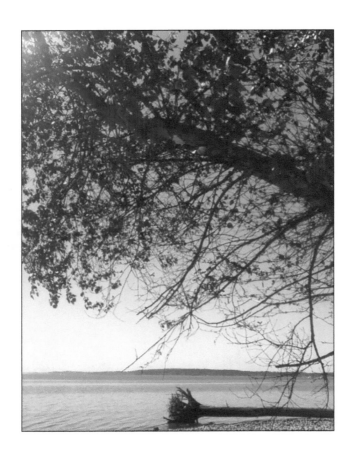

Friday, April 17. 1:46p.m.

The mountain looms majestic on the east horizon.

It is a gently warm day. A pleasure craft cruises slowly by.

Being confined with others involves stamina.

A swallow swoops over the sand.

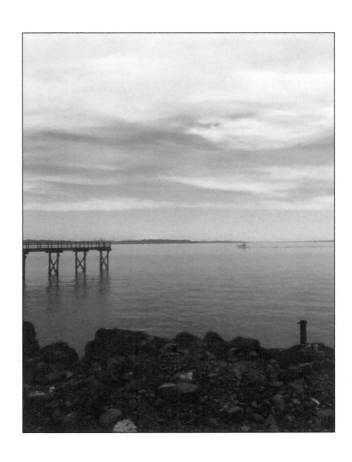

Sunday, April 19. 1:18p.m.

The clouds are puffy white. The city is silent in the distance.

The buildings project from the land like a dystopian image.

Many are restless with the prolonged isolation.

The sun taps the leaves fluorescent.

Monday, April 20. 12:46p.m.

Summer feels close today. Newness fills the air.

A sailboat cuts through the water.

The ducks feed voraciously on the abundant smelt.

Sparrows play in the trees.

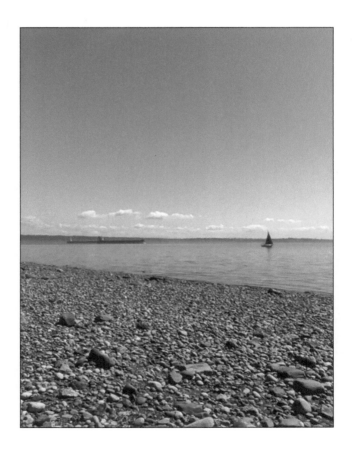

Thursday, April 23. 1:08p.m.

After two days of rain, the beach is warm and sunny.

Offshore, a sea lion calls.

An easterly breeze heralds new direction.

Trains skirt the distant peninsula.

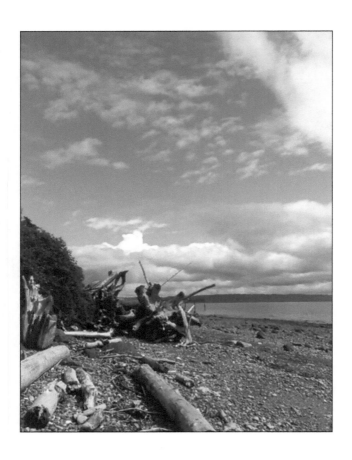

Friday, May 1. 10:46a.m.

The beach is not what it was yesterday.

It will not be the same tomorrow. Yet there is freshness each day.

In this there is change and changelessness.

The clouds are wispy white. The water laps the shore.

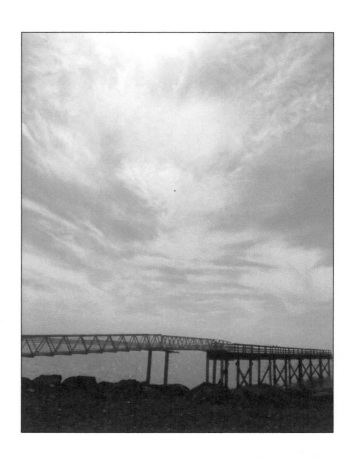

Sunday, May 3. 12:42p.m.

The sun breaks through an overcast sky.

A rumbling has returned to the city across the water.

The beach remains quiet, still.

An ebb tide begins to move.

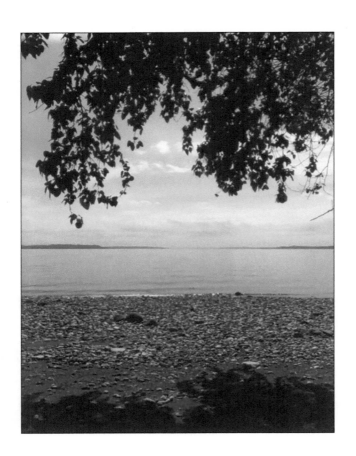

Friday, May 8. 9:34a.m.

It is a sunny, warm morning. The water is sparkling.

The tide is going out to an extreme low.

There is this time with the beach.

Which is now.

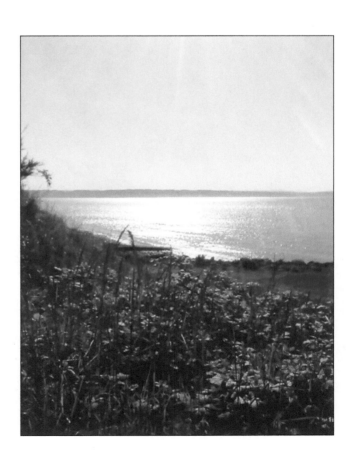

Wednesday, May 13. 1:27p.m.

Barnacles coat the rocks. Silky water calmly laps.

Orange poppies burst from the cliffside.

Swallows weave around the dock.

There is magic in this day.

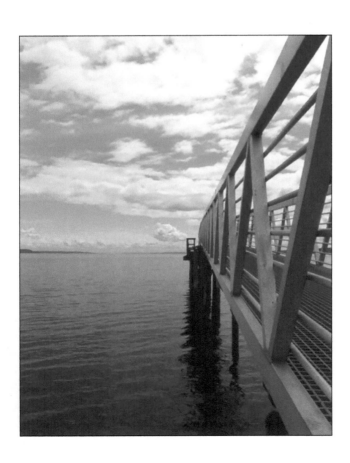

Tuesday, May 19. 2:36p.m.

A balmy afternoon. A container ship passes slowly.

The world slowly re-opens, impatience mixes with caution.

The beach dries quickly after a morning rain.

Two seagulls perch upon a rock.

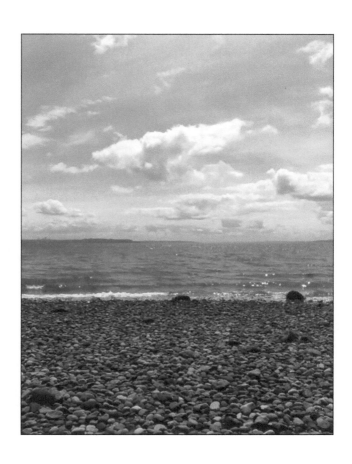

Acknowledgements

Many thanks to my writer's group of over 20 years--5 NW Authors-- for encouraging me to publish this collection of poems, and for their ongoing support of my writing.

To TwoNewfs Publishing for preparing and publishing this poetry book.